Price Guide

for

Miniature Lamps

Price Guide for Miniature Lamps

Combining

Miniature Lamps

by Frank R. and Ruth E. Smith

Miniature Lamps-II

by Ruth Smith

Miniature Victorian Lamps

by Marjorie Hulsebus

Marjorie Hulsebus

4880 Lower Valley Road, Atglen, PA 19310 USA

ISBN: 0-7643-0542-5
Printed in the United States of America

Type set in Futura Md/Futura Bk BT

Published by Schiffer Publishing Ltd.
4880 Lower Valley Road
Atglen, PA 19310
Phone: (610) 593-1777; Fax: (610) 593-2002
E-mail: Schifferbk@aol.com
Please write for a free catalog.
This book may be purchased from the publisher.
Please include $3.95 for shipping.

Please try your bookstore first.

We are interested in hearing from authors
with book ideas on related subjects.

Contents

Introduction

This price guide is intended to help collectors and dealers alike in pricing the values of miniature lamps pictured in the books:

Miniature Lamps by Frank R. and Ruth E. Smith (Schiffer, 1981)

Miniature Lamps-II by Ruth Smith (Schiffer, 1982)

Miniature Victorian Lamps by Marjorie Hulsebus (Schiffer, 1996)

In most cases, the current prices of the lamps have increased since the last edition of each book, but this does not hold true for each and every lamp. Therefore, it seemed necessary to update the last published price guide. To do this, I have called upon seven other collectors/dealers to give their evaluation of the lamps using their expertise, show prices and auction results. This price guide is the result of averaging-out each and every lamp and due to the fact that prices vary from one side of the country to the other, all areas are being represented here.

Each lamp has a number which corresponds to the lamps listed in the above mentioned books with symbols to denote availability or an asterisk to denote any one of the following: "Not Old"; "Incomplete"; "Mismatched"; "Authenticity Questionable" or "Age Questionable". Bases are not being priced in this guide as they are an incomplete lamp. Generally speaking, the price of a base is usually equivalent to one-fifth the cost of the complete lamp.

The prices reflect lamps assumed to be in perfect condition, i.e. slight flakes and roughness excluded. If the lamp in question is shown with a painted decoration, the value of the lamp is reflecting "good paint or decoration". Obviously, if no paint exists, make an allowance for this fact when making your purchase. If the burner or shade or both is noted in the price guide as being incorrect, look for the symbols to indicate the value of the lamp when it is assembled correctly. Art glass lamps shown with matching opalescent chimneys are priced with the chimney shown. If this component of the lamp is missing, the buyer should make an allowance for this when making their purchase. If a lamp has been ground down at the top, or the feet have been ground down at the bottom, both parts are of little value.

There are various full sized finger lamps in all the above mentioned books. Some of us, myself included, attempted to price them when, in fact, they are not miniatures and deserve collectors with more expertise to value them correctly. Although the majority of student lamps shown in the Smith books are not old, there is still a great deal of interest in the auction houses with buyers willing to pay large prices to obtain them. Of the few contributors of this price guide who were willing to price this group of lamps, their values are shown...not with an asterisk to denote the vintage of the lamp but just an evaluation of the lamp itself.

The symbols used for rarity in this guide are as follows:

C -------------------- Common
S -------------------- Scarce
R -------------------- Rare
VR or VVR. ---------- Very Rare and Very, Very Rare
ER. ------------------ Extremely Rare
WB&C -------------- With correct burner and chimney
WCS ---------------- With correct shade
WCB&S ------------ With correct burner and shade

Authenticity questionable can be because of any one
of the following:

Not a lamp of the Victorian Era.

Two bases with one cut off to appear to be matching
shade.

A base for a lamp with an attached reflector not origi-
nally intended to be a complete or original lamp.

A salt shaker or perfume base with fittings; shade
painted to match the base portion.

An old base; a rose bowl cut off at the bottom to
represent the matching shade.

An old collar (and/or burner) replacement for Hong
Kong parts to represent an old base. (Primarily
found on figural bases.)

Any assembled parts such as a font or base, shade,
burner with fitting which have not been seen on at
least one other lamp identically alike.

I highly recommend that any new collectors subscribe
to the publication for miniature lamp collectors entitled
"Night Light" by contacting Bob Culver, 38619 Wakefield,
Northville, MI 48167 and purchase the Smith miniature
lamp books before contemplating any purchases.

Since this price guide is not intended to "set a price on a lamp" but is simply meant to be used as a guide, all of the contributors, author and publisher will not warranty any of the listed prices.

I would like to thank the following collectors and dealers who gave so much of their time and effort in evaluating the lamps:

Frank McWright, collector/dealer who resides in
Bether, CT.

Eileen White, collector/dealer who resides in Chico
Valley, AZ.

Carl Cotting, collector who resides in Vienna, VA.

Fred Reesbeck, collector who resides in River Vale, NJ.

Peter Frenzel, collector who resides in Baldwin, NY.

Bob Culver, collector who resides in Northville, MI.

Kathy Gresko, collector who resides in Spring City, PA.

PRICE GUIDE FOR *MINIATURE LAMPS*

by Frank R. & Ruth E. Smith

SMITH

NO.	DESCRIPTION	PRICE ($)	RARITY
I	Age questionable		R
	Czech - Post WWII		*
II	Left	335	S
	Center	595	S
	Right	500	S
III	Milk glass	300	C
	Lavender satin	1,125	VR
	Pink satin	600	R
	Red satin	475	S
	Amber satin	900	R
	Blue Aquamarine satin	750	R
	Green satin	650	R
IV	Pink csd, possibly one of a kind	4,000	VVVR
1	Early whale oil	550	VR
2	Clear whale oil	175	C
3	Clear finger lamp	175	S
4	London Lamp	70	S
5	Handy clear	55	C
	Colored	100	C
	Right T.E Handy	65	C
6	Clear, burner incomplete	95	S

	WB & C	150	S
7	Little Firefly, wrong shade, left	155	R
	WCS, left	210	R
	Little Firefly, wrong shade, right	125	S
	WCS, right	160	S
8	Firefly chandelier	3,000	VR
9	WMG Firefly	250	S
	Blue	350	S
10	Pink opl.	300	S
11	WMG Pedestal, left	350	R
	Colored m.g. right	350	R
12	Evening Star, left	115	S
	WB & C	150	S
	Evening Star, center	135	S
	WB & C	175	S
	Evening Star, right	115	S
	WB & C	150	S
13	Little Harry m.g. or crystal	125	S
	WCS	175	S
	Cobalt	350	R
14	Little Harry bracket lamp	1,100	R
	Blue - see #H-80	1,400	VR
15	Little Harry	125	S

	Cobalt	325	S
16	Little Favorite, left	145	S
	Little Beauty, right	145	S
17	Little Harry , m.g.	285	R
	Cobalt blue	350	R
18	Authenticity Questionable		*
19	Little Twilight, wrong shade	135	S
	WCS	175	S
20	Improved Banner, clear	75	C
	W.M.G.	85	C
21	Clear glass or flashed red	90	S
22	Clear glass	100	S
	White w/ WMG shade	150	R
	Amber glass w/ Amber shade	250	VR
23	Time & Light See S-II #309,#310	200	C
24	WMG, embossed	150	S
25	Bristol glass	150	S
26	Blue Bristol, wrong shade	150	S
	WCS	200	S
27	Doll house lamp, wrong shade	150	S
28	Blue or green opl. wht. opl. shade	200	S
29	Nutmeg, clear	50	C
	Nutmeg colored	100	S

30	Manila, clear	75	C
	Manila, colored	100	S
31	Brass Saucer	50	C
32	Little Duchess, clear	85	C
	Little Duchess, colored	125	C
33	Green or blue	100	S
V	Ribbed rainbow, left	6,200	VR
	DQMOP rainbow, center	3,800	VR
	DQMOP rainbow, right	4,500	VR
VI	Indian	7,500	VVR
VII	Santa Claus see II-XXXI, II-#349	2,900	R
	Black Coat	2,700	VR
VIII	Cameo w/maidenhair fern, citron	8,500	VR
IX	DQMOP, left	3,500	VR
	Candy stripe, right	1,800	R
X	Decorated m.g.	375	S
	Authenticity Questionable		*
XI	Cranberry	1,500	VR
34	Cup & saucer, clear	125	S
	Amber	225	S
	Blue	500	S
35	Clear glass	150	S
	Colored glass	235	S

36	Little buttercup, clear	65	C
	Blue, amethyst and amber	115	C
	Green & WMG	125	R
37	Clear embossed elephant	130	S
38	Spatter glass	175	S
39	Dec. mg.	100	C
40	Snowflake, clear	300	S
	Snowflake, blue	450	S
	Snowflake, cranberry	500	S
41	Clear, incomplete, see II-#237		*
42	Clear glass	175	S
43	Hobnail finger lamp	150	S
44	Little Jewel, clear	75	C
	Little Jewel, green	125	S
45	Clear	100	S
46	Pickett, blue, amber, Vaseline	200	S
	Pickett, clear	125	S
47	Blue, amber, Vaseline	200	S
	Clear	125	S
48	Clear, full size finger lamp		*
49	Paneled finger lamp	225	S
50	Log cabin, clear see II-#238	350	S
	Amber, blue	750	R

	White opaline	850	R
	Colored opaline	950	R
	WMG	550	S
	Reproductions	25	*
51	Shoe, clear, see II #274	400	R
	Blue	1,000	R
	Amber	850	R
	WMG	700	R
52	Match-holder, clear	450	R
	WMG	600	R
	Blue, amber glass	700	R
53	WMG	50	C
	Colored m.g.	80	S
54	WMG	75	C
	Colored m.g. & custard	100	C
55	Authenticity questionable, left		*
	W.M.G., Colored glass, right	125	S
56	WMG	95	S
	Colored m.g, & custard	135	S
57	Authenticity questionable		*
58	Colored glass	95	S
59	Brass w/reflector	50	C
60	Age questionable		*

61	Tin lamp	50	C
62	Lockwood light	325	S
63	Label		*
64	Acme	50	C
65	Brass lamp	75	C
66	Authenticity questionable		*
67	Brass plated	60	C
68	Pot metal lamp	60	C
69	Brass boudoir lamp	75	C
70	Authenticity questionable		*
71	Authenticity questionable		*
72	Authenticity questionable		*
73	Brass pedestal	50	C
74	Brass pedestal	50	C
75	Crystal Aladdin See II-#21 probably sold with or without ribbed shade	375	R
76	Brass pedestal	50	C
77	Beauty	85	C
78	Comet	85	C
79	Brass barrel	250	R
80	Authenticity questionable	525	*
81	Double burner log	650	R

82	Brass sleigh	650	R
83	Student lamp	1,275	R
84	Brass student lamp	550	R
85	Brass student lamp	500	S
86	Brass double student	525	S
87	Brass log student	850	R
88	Brass double student	1,150	R
89	Brass double student	1,150	R
90	Brass lamp	475	R
91	Gilded bracket	525	R
92	Rayo lamp	300	S
93	Age questionable		*
94	Age questionable		*
95	Brass pedestal	100	C
96	Authenticity questionable		*
97	Brass w/jewels	125	C
98	Brass w/jewels	200	S
99	Authenticity questionable		*
100	Brass w/colored shade	225	S
101	Brass lamp	175	S
102	Brass lamp	175	S
103	Clear stem	50	C
104	Clear stem	50	C

105	Clear stem	50	C
	Colored	100	C
106	Clear stem	50	C
	Colored	100	C
108	Hemstitch heart, clear	125	S
	Hemstitch heart, colored	200	S
109	Beaded heart, six-toed, clear	175	S
	Green & green frosted	285	S
	Green six-toed	300	S
110	Bull's eye, clear	45	C
	Flashed or clear decorated	50	C
	Milk glass	100	C
	Colored glass	115	S
	Colored reproductions	25	*
111	Clear	85	S
	Colored & MG, see II-#412	125	S
112	Clear stem	85	C
	Colored	135	C
113	Clear stem	85	C
	Frosted	100	C
114	Clear stem	100	C
	Frosted	125	C
	Green glass	150	S

115	Clear stem	85	C
	Clear & frosted	125	S
116	Fish-scale, clear	75	C
	Colored glass	150	C
117	Waffle, clear	75	C
	Colored glass	125	S
118	Buckle stem, clear	100	C
	Colored glass	200	S
119	Clear	15	C
120	Clear finger lamp	150	S
121	Clear Acorn	65	C
	Milk glass	125	S
	Mercury glass	150	S
	Opalescent & Amethyst	175	S
122	Milk glass	45	C
123	Milk glass and Goofus	45	C
124	Decorated m.g.	175	S
125	Christmas tree, clear	125	S
	Milk glass	150	S
126	Clear glass, ribbed	125	S
	Milk glass	150	C
127	Pewter w/clear glass	125	C
	Frosted	175	S
128	Milk glass	125	C

129	M. G. Pairpoint	250	S
130	M. G. Pairpoint, See II-#266	225	S
131	Clear glass	100	C
	Milk glass	150	S
132	Clear glass	100	C
	Milk glass	150	C
	Colored glass & Red Flashed	175	S
133	Clear glass	100	C
	Milk glass	150	C
134	Clear glass	100	C
	Milk glass	150	C
135	Clear glass	100	C
	W.M.G. or Blue Flashed (rare)	150	C
136	Clear glass emb.	150	S
137	Pewter ped. clear or W.M.G.	125	S
138	Clear glass	100	C
	Green glass See I-#456 & II-#232	150	C
139	Painted	125	C
	Milk glass	175	C
140	Painted - See I-#131	150	C
141	Painted	150	S
142	Painted hobnail	75	C
143	Lincoln drape	75	C
144	Westmoreland	300	S

145	Westmoreland pedestal	375	S
146	Westmoreland pedestal w/filigree	825	VR
	W/O filigree	700	R
147	Clear glass	400	R
148	Clear & frosted See II-#236	300	S
	Blue m.g.	475	VR
149	Same as #150		
150	Assembled bull's-eye pattern	475	VR
151	Clear glass & frosted	300	S
152	Goofus	125	C
153	M. G. painted or clear	125	C
154	Clear glass	100	S
	Milk glass	135	C
155	Clear glass	100	C
156	Clear glass, milk glass	100	C
	M.G.	125	C
	Green	165	S
157	Clear glass	115	C
	Milk glass	150	C
158	Milk glass embossed	275	S
159	Milk glass embossed & painted	250	S
160	Milk glass embossed & painted	225	S
161	Milk glass embossed & painted	250	S

162	Milk glass embossed & painted	250	S
163	Gothic mug lamp	275	S
	Base in blue m.g.	325	S
164	Clear Gothic Arch	250	S
165	Clear Gothic Arch, See H-#79	250	S
166	Grecian key, clear	100	C
167	Grecian key, clear	125	C
	Colored glass	175	S
168	Grecian key, clear	115	C
169	Grecian key, clear	100	C
	W.M.G.	150	C
170	Cabbage Rose	150	S
171	Clear glass	100	C
172	Clear glass painted	100	C
	W.M.G. painted	125	C
173	W.M.G., Gold Gilt	125	C
174	W.M.G. swirl	250	S
175	Clear glass	100	C
	Milk glass	150	C
176	Milk glass	225	S
	Blue m.g. & custard	300	S
177	Leon , W.M.G.	225	S
	Blue m.g. & custard	300	S

178	Colored m.g. w/filigree	500	R
179	Clear glass	100	C
	Milk Glass	135	S
	Colored/M.G.	165	S
180	Milk glass emb. & painted	225	S
	Colored milk glass	325	S
181	Colored milk glass	325	S
182	White Bristol glass - see #II-217	200	S
183	White m.g. emb., painted	185	C
184	White m.g. emb., painted	250	S
185	White m.g. emb., painted	300	S
186	Satin egg-shell finish dec.	275	S
187	White m.g.	125	C
	Blue m.g.	185	S
188	Milk glass embossed panels	250	S
189	Milk glass embossed panels	275	S
190	Block & dot, clear	100	C
	Block & dot, m.g.	125	C
191	Block & dot, clear	100	C
	Block & dot, m.g.	125	C
192	Mission, clear	65	C
	Mission, m.g.	85	C
193	Apple blossom	250	S

194	Apple blossom	275	C
195	Milk glass embossed	350	C
196	Milk glass embossed	150	C
	Colored m.g.	200	C
197	Milk glass, Fostoria	250	S
198	Milk glass embossed	200	C
199	Clear and painted design	135	S
	M.G. and painted design	185	S
200	Milk glass emb. and painted	250	C
201	Milk glass emb. and painted	275	S
202	Centennial lamp	275	S
	Colored M.G. - see H-#130	400	R
203	W.M.G. plume lamp (old)	225	C
	Colored reproductions		*
204	Clear glass embossed	100	C
	W.M.G. embossed	150	C
205	Clear glass embossed	100	C
	W.M.G. embossed	150	C
206	Sunflower	325	S
	Blue M.G.	450	R
207	W.M.G. emb. and painted	250	S
208	W.M.G. emb. and painted	250	S
209	W.M.G. emb. and painted	275	S

210	W.M.G. emb. and painted	175	C
211	W.M.G. emb. and painted	175	C
212	Colored m.g. w/shell	400	R
213	W.M.G. embossed	325	C
	Red satin glass	400	S
214	Maltese Cross	175	C
	With complete paint	200	C
215	White m.g., windmill & boats	300	C
	Colored m.g. & custard	450	S
216	White m.g. embossed	275	S
	Colored m.g. & custard	400	S
217	W.M.G. brady lamp	325	S
	Colored m.g.	500	S
	Satin glass	575	R
218	Satin finish, See II-#252	375	S
219	Nellie Bly, See H-#78	125	C
220	W.M.G. emb. and painted	325	R
	Orange satin glass	450	R
	Pink glossy cased glass	475	R
221	Blue m.g.	425	R
	Painted m.g.	300	S
222	W.M.G. emb. and painted	300	S
223	W.M.G. emb. and painted	200	C
224	W.M.G. emb. and painted	250	S

225	W.M.G. emb. and painted	250	S
226	W.M.G. emb. and painted	300	S
227	W.M.G. emb. and painted	350	S
228	Fleur-de-lis, clear	125	C
	Fleur-de-lis, m.g.	200	C
229	W.M.G. emb. and painted	275	C
	Colored m.g.	350	S
	Green satin finish M.G.	475	R
230	Acanthus	235	C
	Orange satin glass	425	R
231	Drape, w.m.g.dec.	250	C
	Colored satin glass	325	C
232	W.M.G. emb. and painted	350	S
233	Authenticity questionable		*
234	W.M.G. embossed	275	C
	Colored m.g.	350	S
235	Authenticity questionable		*
236	W.M.G. emb. and painted	250	C
237	W.M.G. emb. and painted	285	S
238	W.M.G. emb. and painted	300	S
239	W.M.G. emb. and painted	350	S
240	W.M.G. embossed and dec.	250	C
	Colored m.g.	350	S
241	W.M.G. and dec.	315	S

	Colored M.G.	400	R
242	Snail, painted m.g. or frosted	350	S
	Red Satin	425	S
243	W.M.G. embossed	300	C
244	W.M.G. embossed, Nara	300	C
245	W.M.G. emb, See II-#258, Elsie	300	S
246	W.M.G. embossed, Erminie	750	VR
247	W.M.G. embossed, See H-#126	350	S
248	W.M.G. emb.hang lamp, Victoria	3,800	VR
249	Authenticity questionable		*
250	W.M.G. embossed Diana	475	R
251	Doll house lamp	425	R
252	Authenticity questionable		*
253	Authenticity questionable		*
254	Clear glass painted	150	C
255	W.M.G. embossed, custard	275	C
	Colored m.g.	375	S
	Opl. pink, Vaseline & jade	500	R
256	Pewter w/m.g.	170	C
	Clear glass	125	C
257	W.M.G. embossed	250	C
	Colored glass	325	C
	Custard glass, Blue M.G. (S)	350	C
258	Embossed, colored, See H-#215	325	S

259	Pewter w/frosted paint	175	C
260	Embossed colored	325	S
261	Mismatch		*
262	Embossed clear glass	150	C
	Colored glass and custard	300	C
263	W.M.G. embossed	325	S
	Blue m.g. custard	425	R
264	W.M.G. emb. and painted	375	R
265	W.M.G. emb. and painted	275	S
266	W.M.G. emb. and painted	350	S
267	W.M.G. ribbed & embossed	325	R
268	W.M.G. embossed, lion head	325	S
269	W.M.G. embossed	375	R
270	W.M.G. decorated as shown	300	R
	With matching shade See H-#145	375	R
271	W.M.G. emb. and painted	375	S
272	M.G., See II-#231	300	C
273	W.M.G. emb. and painted	350	S
	Red satin glass	450	S
274	W.M.G. emb. and painted	300	S
275	Eagle lamp all color combinations	400	S
276	Painted W.M.G. or translucent	300	C
	Green m.g., Blue m.g.	350	S
277	Basket weave w/flared top	225	S

278	W.M.G. basket design	200	C
	Clear glass	125	C
279	Colored cased glass	700	S
	Satin glass	725	
	Green carnival glass	785	VR
280	M.G. emb., pink satin finish	500	R
281	W.M.G. embossed shell pattern	300	S
282	W.M.G. embossed	300	S
	Colored mg. & custard	400	S
283	W.M.G. embossed	325	S
284	Red satin glass	225	C
	Blue or green satin glass	400	S
285	Brass w/red satin glass	500	S
	Pink, blue or green satin glass	650	S
286	Cosmos, clear or frosted	75	C
	Milk glass painted	275	C
	Yellow or pink cased glass	575	S
287	Tulip lamp m.g., Red satin	385	S
	Green opalescent	550	S
	Overshot glass	600	R
288	Red satin embossed	550	S
	Orange satin embossed	650	R
289	Blue, green or pink m.g.	400	VR
290	Spatter glass w/fish net embossed	650	R

291	Porcelain decorated	375	S
292	Spider Web Fostoria, frosted	350	S
	Frosted & enameled	450	S
	Milk glass dec.	325	S
	Red satin glass	450	S
293	Pink satin swirl	300	S
	Clear satinized reproductions		*
294	Clear spatter	450	S
	Honey spatter glass	550	S
	Blue or cranberry	625	S
295	Milk glass embossed	375	S
296	Sylvan, W.M.G. painted	200	C
297	W.M.G. ribbed	250	C
	Colored m.g. or custard	350	C
298	Honey spatter w/silver filigree	975	VR
	Cranberry or Blue	1,125	VR
299	White satin glass ribbed	375	S
	Blue or pea-green satin glass	400	S
300	Light green dec. satin glass	500	R
301	W.M.G. covered w/silver filigree	700	R
	Colored m.g. w/silver filigree		
	See H-#356	1,075	VR
302	W.M.G. decorated	400	S
	Red satin glass	475	S

303	W.M.G. decorated	400	S
	Satin glass	475	S
304	W.M.G. decorated	450	S
305	Pairpoint decorated	850	R
306	Three tier banquet	650	R
307	W.M.G., no paint	350	S
	W.M.G. full paint	475	S
308	W.M.G. decorated	275	C
309	Pan-Am lamp, various colors	475	S
310	W.M.G. decorated	325	S
	Blue or green m.g.	385	S
311	W.M.G. decorated	375	S
312	W.M.G. decorated	350	S
	Blue or green m.g. dec.	475	R
313	W.M.G. decorated - see Fig. X	350	S
314	W.M.G. decorated	375	S
315	W.M.G. decorated	300	C
316	W.M.G. decorated	300	C
317	W.M.G. decorated	300	C
318	W.M.G. decorated	300	S
319	W.M.G. decorated	325	S
320	W.M.G. decorated , See II-#397	375	S
321	W.M.G., angel decoration	500	R
322	W.M.G., angel decoration	525	R

323	Prayer lamp	425	S
324	W.M.G., angel decoration	450	S
325	W.M.G., embossed, angel dec.	375	S
326	W.M.G. peg lamp, angel dec.	400	R
327	White Bristol glass - see #450	325	S
328	Cased glass decorated	500	S
329	W.M.G. decorated	425	R
330	W.M.G., Pairpoint Mt. Wash.	525	S
331	W.M.G., Pairpoint Mt. Wash.	525	S
332	W.M.G. dec. See II-#XXXIX	550	R
333	W.M.G. decorated	375	S
334	W.M.G. decorated	465	R
335	Porcelain & W.M.G. dec.	400	S
336	Bristol glass dec.	375	S
337	W.M.G. dec. See I-#348	450	S
338	Mismatch, See H-#56		*
339	Bristol glass decorated	225	C
340	W.M.G. decorated	175	C
341	W.M.G. Age questionable	150	C
342	W.M.G. Age questionable	150	C
343	W.M.G. decorated	125	C
	Colored m.g. & custard	200	S
344	W.M.G. decorated	325	S
345	Satin finish m.g.	325	S

	Frosted clear glass	275	S
346	Dec. m.g. or cased glass	500	S
347	W.M.G. decorated	350	S
348	W.M.G. dec. See I-#337	500	R
349	W.M.G. decorated	275	S
350	Colored m.g. decorated	375	S
351	W.M.G. decorated	375	S
352	W.M.G. emb. & dec. See I-#569	400	S
353	W.M.G., emb. & painted	350	S
354	W.M.G. decorated	350	S
355	W.M.G. decorated, See H-#184	350	S
356	Colored m.g. decorated	425	S
357	Colored m.g. decorated	425	S
358	Colored m.g. decorated	450	S
359	Colored m.g. decorated	450	S
360	W.M.G. decorated	350	S
361	Colored m.g decorated	425	S
362	Bristol glass decorated	375	S
363	W.M.G. decorated	375	S
364	Authenticity questionable		*
365	Blue m.g. embossed, dec.	350	S
366	Not Old		*
367	Colored glass	425	S
	Cased End of Day	525	S

368	Beaded End of Day (top cut off)	475	S
369	Clear glass, smoked 1930's	175	*
	Milk glass, olive drab 1930's	185	*
	Cranberry glass (green $375 - R)	375	C
	End of Day	500	S
370	Beaded swirl w/overshot, age questionable		*
371	Painted clear glass	150	C
372	Colored m.g., custard	475	S
373	Colored m.g., custard	475	S
374	W.M.G. embossed	350	S
	Cased glass	550	S
	Red satin glass	475	S
375	Pink or Blue cased glass	800	S
	Yellow or deep rose, See II-#XXVI	925	R
	Apricot cased	1,075	R
376	Three-tier banquet	725	S
377	Pink cased glass	1,300	S
	Blue or yellow cased glass, See H-#427	1,500	R
378	Red cased glass	600	S
379	Yellow or pink cased embossed	750	S
380	White satin glass decorated	475	S
	Blue satin glass decorated	525	S

381	Satin glass w/silver filigree base	725	R
382	Authenticity questionable		*
383	Acme, colored m.g.	575	S
	Cased glass	650	S
384	Colored m.g.	450	S
	Cased or satin glass	575	S
385	Cased or slag, colored	450	C
	Satin glass	450	C
386	Pink, maroon, yellow or blue	1,100	R
	Chartreuse cased	1,325	R
387	Amber w/satin finish	450	S
388	Florette cased, pink, green or blue	600	S
	Florette blue mg.	575	S
389	Pansy ball, pink, blue, yellow satin	600	S
	Satin cased glass, See II-#403	650	S
390	Melon ribbed satin, pnk, yell., blue	575	S
	Glossy cased glass	600	S
391	Undecorated yellow	625	S
	Dec. cased, yell., pink maroon	725	S
	Orange & Blue	825	R
392	Satin glass emb., white or blue	400	S
393	Satin glass dec. See H-#142	325	C
394	Satin glass , pink, yellow, blue	475	S
	Glossy cased glass	500	S

	Iridescent green	600	R
	Base w/silver filigree, See H-#355	850	R
395	Idaho satin emb., ivory	600	R
	Raspberry or blue	800	R
396	Milk glass embossed, See II-#257	350	S
	Blue satin glass	500	R
397	Red satin glass	425	S
	Reproduction, peach satin glass		*
398	Satin glass	475	S
	Base w/silver filigree	700	R
399	Red satin embossed	475	S
	Orange or blue satin	650	R
400	Red satin beaded drape	275	S
	Green, or pink satin (blue -$400)	375	C
	Reproduction, cased colored		*
401	Red satin glass	450	S
402	Blue satin embossed	575	R
403	Cased beaded drape, not old		*
404	Pink opaline dec.	600	S
405	Red satin	450	S
	Frosted crystal	400	S
406	Satin glass embossed	400	S
407	White opaline	525	R
408	Opaline glass, pink or blue	550	S

409	Opaline glass, pink blue or white	550	S
410	Opaline glass, pink or blue	600	R
411	Mismatch		*
412	Authenticity questionable		*
413	Overshot , enamel dec.	625	R
414	Overshot , green or cranberry	850	R
415	Frosted swirl	325	S
416	Frosted decorated	400	S
417	Rainbow ribbed	875	R
418	Clear painted	150	S
419	Not old		*
420	Frosted glass w/enamel dec.	375	S
421	Iridescent swirl	525	R
422	Iridescent, enamel dec.	500	S
423	Iridescent glass, red or honey	575	R
424	Iridescent, enamel dec.	450	S
425	Iridescent green embossed	550	S
426	Clear glass painted	375	S
427	Clear glass painted	400	S
428	White overshot dec.	575	R
429	White overshot dec.	550	R
430	Clear, satin finish , dec.	450	S
431	Royal Ivy, clear	500	R
	Rubina	625	S

	Rubina frosted	665	S
	Pink, yellow, white spatter	800	R
432	Twinkle, Blue, green or amethyst	300	C
	Amber, w/ or w/out handle	400	VR
433	Honeycomb glass, See H-#301	550	S
434	Age questionable		*
435	Green glass, age questionable	150	C
436	Green glass, age questionable	150	C
437	Cranberry panel	400	S
438	Cranberry, hexagon base	400	S
439	Cranberry glass	375	C
	Yellow opalescent	600	R
	Amberina	475	S
	Green or Amber	325	S
	W.M.G.	250	R
440	Amberina	600	S
	Undecorated cranberry or green	500	S
441	Cranberry or green glass, dec.	600	R
442	Cranberry	425	S
443	Colored glass	600	R
	Yellow & white spatter	1,000	R
444	Cranberry or blue, enamel dec.	950	R
445	Colored glass embossed	425	S
446	Color glass emb, blue or cranberry	450	S

447	Colored glass decorated	450	S
448	Colored glass decorated	325	S
449	Colored glass embossed	300	S
	White m.g.	250	C
450	Colored glass decorated	325	S
451	Colored glass decorated (top cut off)	325	S
452	Colored glass decorated, see#187	200	S
453	Colored glass embossed	250	C
454	Colored glass, geometric dec.	275	S
455	Porcelain, grn. or blue, Sim. II-#XLVII	285	S
456	Green, See I-138 & II-#232	250	S
457	Colored glass decorated	375	S
458	Colored glass decorated	450	S
459	Top cut off, See H-#219		*
460	Cranberry gl., see H-#217/#218	600	S
461	Cranberry, jack-in-the-pulpit	825	R
462	Cranberry glass	575	S
463	Lighthouse lamp	575	R
464	Colored glass embossed	450	S
465	Cranberry glass (top cut off)	500	S
466	Green or white opl. diam. pattern	450	S
	Cranberry or ruby	550	S
467	Colored glass embossed	175	C
	Clear	100	C

468	Colored glass, swirl pattern	300	S
469	Colored glass, decorated	400	S
470	Green or blue dec. see#II-#496	475	S
	Cranberry glass	550	S
471	Spanish lace or snowflk., clear opl.	675	R
	Blue or Vaseline	1,000	R
	Cranberry	1,500	VVR
472	Colored glass dec. See H-#168	475	S
	Cranberry	550	S
473	Blue Span. Lace w/silver filigree	1,500	R
474	Cranberry Snowflake		
	w/filigree	1,600	R
	Clear	1,150	R
475	Colored glass, swirl	400	S
	Clear glass	275	S
476	Amber or blue glass, beaded	600	R
	Clear glass	375	S
477	Colored glass	450	S
	Clear glass	300	S
478	Famous, clear	375	S
479	Colored glass	475	R
	Clear	350	S
480	Cathedral lamp, colored glass	500	S
	Vaseline glass	600	R

	Clear font w/color shade and stem	775	R
	Clear glass	375	S
481	Colored glass	750	R
	Clear glass	375	S
482	Colored glass	375	S
	Vaseline glass	475	R
	Clear glass	300	S
	Reproductions		*
483	Dresden base decorated	475	R
484	Porcelain house, blue or green	675	R
485	Bisque boy, See II-#342	500	R
486	Jasper ware figural	425	R
487	Porcelain man figural	325	R
488	Reclining elephant, no paint	525	S
	Original paint	650	R
489	Bisque girl & boy	625	R
490	Skeleton lamp, either size	6,100	VR
491	Columbus lamp	4,000	VVR
492	Authenticity questionable		*
493	Embossed owl, clear	1,075	R
	W.M.G.	1,400	R
	Blue or green m.g.	1,700	VR
494	Bull dog, frosted	1,500	VVR
	Milk glass	2,000	VVR

495	Nippon Owl	2,600	VR
496	Porcelain cat lamp	475	R
497	Owl lamp, green paint	1,325	S
	Owl lamp, gray paint	1,425	S
	Orange satin	3,100	VVR
498	Authenticity questionable		*
499	Swan lamp, white milk glass	2,100	R
	Colored milk glass, pink satin	2,800	R
500	Pottery pig	900	R
501	Owl head, milk glass	300	R
	Owl head, frosted	275	R
502	Opalescent threaded glass	2,000	VR
503	Opalescent glass, pink or blue	1,200	VR
504	Chrome green aventurine	1,025	VR
505	Threaded green/red glass	2,850	VR
506	Colored hobnail,		
	See H-#394 & #395	675	R
507	Authenticity questionable		*
508	Clear opl. Seaweed pattern	1,125	R
	Cranberry Seaweed pattern	2,300	R
509	Clear opl. reverse swirl	825	R
	Colored opl. reverse swirl	1,625	R
510	Coindot, clear opl.	1,075	R
	Coindot, blue opl.	1,900	R

	Description	Price	Rarity
	Coindot, cranberry	2,000	R
511	Cranberry opl. stripes	1,100	R
512	Clear opl. swirl	525	S
	Blue, Vaseline opl.	800	R
	Amber opl.	500	R
513	Clear opl . glass	900	S
	Blue opl. glass	1,400	S
	Cranberry	1,800	S
514	Pink, Yell., or Blue opl. see H-#302	1,700	R
	Cranberry	1,525	VR
515	Opl. pink and clear strips	3,200	VR
516	Cranberry w/opl, stripes	1,100	R
517	White opl., matching chimney	1,650	R
	Without matching chimney	1,400	R
518	Vaseline opl. windows	1,350	R
519	Cranberry opl. stripes	1,325	R
520	Vaseline opl.	1,750	R
521	Blue opl. dec.	1,300	R
522	Pink & Green opl, match. chimn.	3,000	VR
523	Blue opl. matching chimney	1,975	R
524	Blue opl. matching chimney		
	See H-#337	2,000	R
525	White m.g. w/amber	1,150	R
526	Cranberry w/matching chimney	1,600	R

527	Cranberry diamond pattern,		
	See H-#338	1,450	R
528	Candy-stripe	1,800	R
529	Candy-stripe	1,800	R
530	Pink cased swirl	2,000	VR
531	White cut velvet, blue feet	1,500	R
	Blue or yellow cut velvet,		
	See H-#327	1,800	R
	Enamel decor.	1,950	R
532	White satin glass	1,500	R
533	Yellow cut velvet	3,300	VVR
534	Blue cut velvet	2,600	VR
535	Cranberry, diamond pattern	1,425	R
536	Cranberry glass, amber, green	1,450	R
	Amberina glass	2,000	R
	Pink Opaline, gr. feet	2,500	R
537	Sterling silver/cranberry,		
	matching chimney.	1,050	R
538	Cranberry	1,450	R
	Amberina glass	2,000	R
	Opalescent glass	2,400	VR
539	Green to clear, o/shot	1,625	R
	Pink opaline glass	2,000	R
540	Cranberry glass	1,250	R

49

541	Raspberry or blue satin	1,550	R
	Ivory satin	1,200	R
	Vaseline	1,400	R
542	Colored cased glass, see II-#XLVI	1,500	R
543	Amber and honey swirl	1,600	R
544	Butterscotch & honey, see -#336	2,600	R
545	Cobalt ribbed swirl, See II-548	1,500	R
546	Cranberry swirl	1,375	R
547	End of day cased or overshot	1,400	R
	Cranberry, blue or yellow m.g.	1,400	R
548	End of day cased	1,300	R
549	End of day	1,500	R
550	Millefiori, Age questionable		*
551	End of day	1,300	R
552	Incomplete		*
553	Cut overlay	5,000	VR
554	Gold base/pink shading shade	575	R
555	Vasa Marrhina	1,250	R
	Butterscotch satin	1,250	VR
	Domed shade variation	1,500	VR
556	Silver base /swirl dec. shade	1,800	R
557	Yellow satin glass dec.	1,100	R
558	Authenticity questionable		*
559	Brass banquet lamp	500	R

560	Brass/colored m.g. dec., see H-#300	650	R
561	Brass base w/dec. shade	550	R
562	Green & pink opaline	2,150	VR
563	Satin glass, dark rose or pink	1,700	VR
564	Satin glass, embossed shell	1,900	VR
565	Satin glass, colored, embossed	1,900	VR
	Decorated m.g.	800	VR
566	Salmon cased hobnail	2,350	VR
567	Pink or green overshot fleur-de-lis	2,700	VVR
568	Pink satin glass embossed	1,475	R
	Chartreuse satin glass	1,650	R
569	Chartreuse satin glass		
	embossed	1,650	R
	Pink satin, See I-#446	1,450	R
570	Chartreuse embossed	1,675	R
	Pink satin	1,450	R
571	Crown Milano, see II-#398	3,250	VR
572	Yellow satin, See H-#308	1,575	R
573	Satin glass, top cut off, See #568		*
574	Fireglow, See II-#527 & H-#309	2,200	VR
575	Mismatch		*
576	Chartreuse or Pink Verre Moire,		
	(Nailsea)	4,900	VVR
577	Rose Verre Moire (Nailsea)	3,300	VR

51

578	Pink, blue or white Nailsea	3,000	VR
579	Red satin	2,000	VR
580	White Verre Moire (Nailsea)	2,400	VR
581	Blue Verre Moire (Nailsea)	2,250	VR
	Cranberry Nailsea	2,250	VR
582	Red & beige Verre Moire (Nailsea)	2,500	VR
583	Green satin dec.	950	S
584	Green or cranberry		
	w/gold enamel dec.	2,100	R
585	Frosted decorated glass	1,900	R
586	Tiffany lamp	2,400	R
587	Unassembled		*
588	Mother -of-pearl , ribbed	2,600	VR
589	Mother-of-pearl, wrong fittings	1,700	R
590	Brass pedestal, green satin	850	R
591	Chartreuse DQMOP w/silver base	1,900	VR
592	Satin Mother-of-pearl	1,900	VR
593	Rainbow DQMOP, See Fig. V (ctr.)	3,650	VR
594	DQMOP, Blue, Pink or yellow	2,000	R
	Chartreuse	2,400	R
595	Apricot shading DQMOP	2,000	R
	Rainbow, See I-V	4,500	VR
596	Yellow DQMOP,		
	(book misprint color)	4,600	VVR

597	M.O.P. Raindrop, blue or white	2,200	R
598	M.O.P. Raindrop, white	1,900	R
599	DQMOP, colored, left	2,150	VR
	DWMOP, colored, right,		
	see H-#307	2,300	VR
600	Colored M.O.P. Raindrop	2,075	R
	White	1,900	R
601	Colored M.O.P. Raindrop	1,675	R
	White	1,475	R
602	Colored M.O.P. Raindrop	2,075	R
	White	1,900	R
603	M.O.P. Raindrop	1,850	VR
604	Royal Worcester base,		
	Baccarat shade	700	R
605	Baccarat Lamp	600	R
606	Baccarat Lamp	700	R
607	Authenticity questionable		*
608	Burmese Webb decorated	10,000	VVR
609	Authenticity questionable		*
610	Burmese Webb decorated	10,000	VVR
611	Cameo, tri-color, Webb	15,000	VVR
612	Cameo, Cinnamon or Lavender	10,000	VVR
613	Incomplete		*
614	Incomplete		*

615	Incomplete		*
616	Incomplete		*
617	Incomplete		*
618	Incomplete		*
619	Incomplete		*
620	Incomplete		*
621	Incomplete		*
622	Incomplete		*
623	Incomplete		*
624	Unassembled		*
	Clear		*
625	Glow lamp complete	75	C
	Colored	140	C
626	Clear glow lamp	100	C
627	Unassembled, See II-30		*
628	W.M.G. glow lamp	125	C
	Colored	150	C
629	Fairy lamp Verre Moire (Nailsea)	300	C
630	Vapo-Cresolene	45	C
	In original box	65	C

PRICE GUIDE
FOR *MINIATURE LAMPS* II

by Ruth E. Smith

SMITH

NO.	DESCRIPTION	PRICE ($)	RARITY
1	Lithograph lamp	170	S
2	Tin lantern	125	S
3	Brass lantern	95	C
4	Star Tumbler lamp	200	S
5	Tin lantern	75	C
6	Brass lantern	175	S
7	Brass lantern	150	S
8	Baby lantern	450	R
	Brass frame lantern (Incomplete)	100	R
	If complete	225	R
	Brass font lantern, See H-#98	250	S
	Brass font lantern	100	C
9	Brass lantern, clear globe	125	C
	Colored globe	235	R
	Green	275	R
	Cobalt blue, teal, amethyst	350	R
	Red	825	R
	Amber	900	R
10	Baby brass lantern	450	R
11	Brass lantern	100	S
12	Incomplete		*
13	Flashlight	180	R

14	Jeweler's lamp	50	C
15	Jeweler's lamp, colored	55	C
16	Cobalt jeweler's lamp	45	C
17	Aladdin lamp cigar lighter	185	S
18	Authenticity questionable		*
19	Authenticity questionable		*
20	Authenticity questionable		*
21	Clear Aladdin lamp with shade	550	VR
	Without shade	400	R
22	Cigar lighter without strikers	275	S
	With strikers	375	S
23	Cigar lighter	375	S
24	Scent bottle		*
25	Scent bottle		*
26	Herringbone ribbed	100	S
27	Authenticity questionable		*
28	Glow lamp, See I-#628	150	C
29	Glow lamp, See I-#628	150	C
30	Glow lamp	150	S
31	Glow lamp	100	S
32	Authenticity questionable		*
33	Authenticity questionable		*
34	Lamp fillers	155	C
35	Glass lamp	75	S

36	Glass lamp	75	S
37	Little sunbeam	100	S
38	New York Safety lamp	100	S
39	The All Night Lamp	100	S
40	Union	125	S
41	Little Joker	135	S
42	Little Andy, wrong shade	125	S
	With correct shade	175	S
43	Little Favorite	200	S
44	Little Favorite, wrong shade & burner	175	S
	WCB & S	225	S
45	Twilight	185	S
46	Night Watch	135	S
47	Night Watch, wrong shade & burner	135	S
	WBC & S	175	S
48	Night Watch, clear	135	S
49	Little Banner, wrong shade & burner	35	C
	WCB & S	75	C
50	Advance	150	S
51	Improved Little Wonder, wrong sh. & br.	100	S

	WCB & S	150	S
52	Little Wonder	140	S
53	Firefly, bracket	625	R
54	Firefly	125	R
55	Firefly, incomplete	125	S
56	Firefly, tin	130	S
57	Evening star, complete,		
	See I-#12	150	S
58	Moon Light, wrong shade		
	& burner	100	S
	WCB & S	150	S
59	Vienna, Wrong shade	100	S
	WCB & S	150	S
60	Referred to as Sandwich, See I-#11	325	R
61	W.M.G. dec. pedestal	350	S
62	Blue opaline	225	S
63	Pink opaline	325	R
64	W.M.G. Emb.	165	S
65	Brass base, Japanned green	115	S
66	Authenticity questionable		*
67	White Bristol glass	175	S
68	Wide Awake, colored	150	S
	W.M.G w/W.M.G. chimney	175	S
69	Little Pet, wrong shade & burner	100	S

	WCB & S	150	S
70	Empire, clear, as shown	150	R
	"Aladdin's Lamp", same as above	150	R
71	Empire, wrong chimney	125	S
	W/ correct chimney	165	S
72	Empire, wrong shade & burner	125	S
	WCB & S	165	S
73	W.M.G. complete, right	225	*
	Incomplete		*
74	Incomplete		*
75	Clear glass	30	C
76	W.M.G.	40	C
77	W.M.G.	40	C
78	W.M.G.	85	C
79	Clear glass	40	C
80	Incomplete		*
81	W.M.G., See II-78	85	C
82	W.M.G. painted, incomplete	40	C
I	Cameo, Citron, Stevens		
	& Williams	12,000	VVR
II	Peachblow, decorated	3,400	VR
III	Mother-of-pearl, Stevens		
	& Williams	3,300	VR
IV	Verre Moire, (Nailsea)	3,350	VR

V	Peachblow , See H-#434	3,500	VR
VI	Clear rainbow	2,500	VR
83	W.M.G.	40	C
84	W.M.G. embossed	40	C
85	W.M.G. embossed	40	C
86	W.M.G. embossed	40	C
87	Authenticity questionable		*
88	Blue glass	40	C
VII	Rainbow satin glass embossed	3,650	VR
VIII	Pink cased glass	1,750	R
IX	White satin glass, corolene dec.	5,000	VVR
X	Blue or cranberry cased w/petals	3,500	VR
XI	Mother-of-pearl colored satin glass	2,800	R
XII	DQMOP, Blue, Yellow	3,700	VR
	DQMOP, deep rose or pink	3,700	VR
89	Authenticity questionable		*
90	Clear glass, tin saucer	125	S
91	Clear glass, tin saucer	125	S
92	Sunlight, W.M.G. or blue, see H-#12	150	S
	Clear	115	S
93	Clear glass	125	S
94	Clear glass, with burner/chimney	225	S
XIII	Vaseline opl , glass	2,500	VR
XIV	Vintage questionable	500	*

XV	Blue & white cased, ribbed	3,100	VR
XVI	Vintage questionable		*
XVII	Three-tier satin glass, decorated	4,300	VR
XVIII	Overshot, enamel dec.	1,150	R
95	Clear glass	75	S
96	Clear glass	100	S
97	Authenticity questionable		*
98	Clear glass	100	C
	Colored glass	150	S
99	Blue, Amber honeycomb	150	S
	Cobalt, Cranberry	185	R
	Colored Glass	100	S
XIX	Mary Gregory dec., Age questionable		*
XX	Colored opl glass dec.	850	R
XXI	Green glass, possibly Moser	600	R
	Cranberry	700	R
XXII	Overshot, blue	1,250	R
	Cranberry	1,350	R
XXIII	Cranberry , enamel dec.	750	R
XXIV	Colored opl. glass emb.	900	R
	Clear	650	R
101	Authenticity questionable		*
102	Clear glass	175	S
103	Clear glass	75	C

	Colored glass	125	S
XXV	Millefiori, vintage questionable		*
XXVI	Cased glass, See I-#375	925	R
XXVII	Authenticity questionable, see I-#572		*
XXVIII	DQMOP, colored	1,750	R
XXIX	Silver base, satin shade	800	R
XXX	Baccarat, shade incorrect		*
104	W.M.G. brass saucer	125	S
105	W.M.G. dec.	100	C
106	W.M.G. dec	100	C
107	Cranberry Honeycomb	200	S
108	Opaline glass dec.	175	S
109	Green m.g. dec. full size	125	S
XXXI	Santa lamp See I-#VII & II-#349	3,500	VR
XXXII	W.M.G. decorated	550	R
XXXIII	Bristol glass decorated	450	R
XXXIV	Colored opl. ribbed	1,600	VR
XXXV	Blue glass, enamal dec.	600	R
	Green pedestal decorated	600	R
110	Incomplete		*
111	Embossed, full size	150	S
112	Cased, embossed, full size	225	S
113	Clear glass, full size	150	S
114	Authenticity questionable		*

115	Clear glass	100	C
XXXVII	Colored satin glass, embossed	1,800	R
XXXVIII	Colored m.g. decorated	600	R
XXXIX	W.M.G. dec. See I-#332	550	R
XL	End of Day or colored glass	600	R
XLI	Amber glass, embossed	700	R
XLII	Opl. colored glass	650	R
XLIII	Colored glass, ribbed	550	R
116	Clear glass	125	S
117	White opl "coindot"	400	R
	Blue opl.	500	R
	Cranberry	600	R
118	Authenticity questionable		*
119	Rainbow finger lamp, full size	425	S
120	Clear glass embossed	750	R
XLIV	Colored cased, See II-#516	800	S
XLV	Cranberry opalescent	1,200	R
XLVI	Cased glass, See I-541 & 542	1,500	R
XLVII	Porcelain, See I-455 & II-244	375	S
XLVIII	White or pink satin glass dec.	750	R
XLIX	W.M.G. dec., see II-#517	600	R
L	Colored satin glass, emb	1,600	R
121	Vintage questionable		*
122	Brass lamp, age questionable	35	C

123	Authenticity questionable		*
124	Brass saucer	45	C
125	Brass, with burner/chimney	50	C
126	Brass saucer	50	C
127	Brass lamp	50	C
128	Brass lamp	40	C
129	Brass lamp	40	C
130	Brass saucer	40	C
131	Tin lamp	40	C
132	Brass lamp	40	C
133	Brass lamp	40	C
134	Nickel plated	50	C
135	Acme brass lamp	50	C
136	Brass lamp	50	C
137	Brass lamp	50	C
138	Brass-Plated, see I-#67	70	C
139	Nickel plated, questionable		*
140	Brass, questionable		*
141	Brass lamp	75	S
142	Hanging reflector lamp	75	S
143	Brass lamp	50	C
144	Tin/brass	40	C
145	Little queen, saucer lamp	150	S
146	Brass plated Jr. lamp	150	S

147	Brass lamp	100	S
148	Incomplete		*
149	Incomplete		*
150	Tin pedestal	40	C
151	Brass pedestal	40	C
152	Nickel plated	40	C
153	Copper peg lamp	75	S
154	Brass stem lamp	50	C
155	Brass stem, colored font	125	S
156	Brass stem, colored font	125	S
157	Brass stem, colored font	125	S
158	Incomplete		*
159	Clear stem, embossed	150	S
160	Clear stem, embossed	150	S
161	Clear stem lamp	125	S
162	Clear stem lamp	50	C
163	Clear stem lamp	50	C
164	Clear stem lamp	125	S
165	Clear stem lamp	125	S
166	Clear stem lamp	125	S
167	Clear stem lamp	125	S
168	Clear stem lamp	125	S
169	Clear stem lamp	125	S
170	Clear stem lamp	125	S

171	Clear stem lamp	100	S
172	Clear stem lamp	100	C
173	Clear stem lamp	100	C
174	Clear stem lamp	100	C
175	Clear stem lamp	75	C
176	Clear stem lamp	50	C
177	Clear stem lamp	50	C
178	Clear stem lamp, see I-#104	60	C
179	Clear stem lamp	50	C
180	Painted bull's eye	50	C
181	Clear stem lamp, full size	125	S
182	Clear, not an old lamp		*
183	Clear, not an old lamp		*
184	Clear, not an old lamp		*
185	Clear, not an old lamp		*
186	Clear, not an old lamp		*
187	Authenticity questionable		*
188	Clear	45	C
189	Authenticity questionable		*
190	Clear, not an old lamp		*
191	Incomplete		*
192	Authenticity questionable		*
193	Age questionable		*
194	Full size lamp		*

195	Colored glass with shade	125	C
	without shade	75	C
196	Colored glass	125	C
197	Mismatch		*
198	Mismatch		*
199	Colored glass	150	S
200	Colored glass	100	S
201	Authenticity questionable		*
202	Brass base	25	C
203	Colored glass	125	C
204	Colored glass	125	C
205	Clear, diamond pattern	175	S
	Colored glass	275	S
206	Authenticity questionable		*
207	Clear base, full size	75	C
208	Authenticity questionable		*
209	Full size lamp		*
210	Age questionable		*
211	Age questionable		*
212	Colored base, clear shade	75	S
213	Incomplete	150	*
214	Colored glass See H-#141	225	S
	White milk glass	200	S
215	Colored , See I-#1 vintage questionable		*

216	Age questionable		*
217	Colored glass	250	S
218	Twinkle, decorated, See I-#432	325	S
219	Colored glass	150	C
220	Authenticity questionable		*
221	Authenticity questionable		*
222	Clear glass, embossed	150	S
223	Duchess	125	S
224	Cambridge Catalog		
	shows plain chimney	125	C
225	Clear glass	100	S
	Colored glass	150	S
226	Colored glass see H-#122, #123	200	S
227	Colored, See I-#219 & II-#497	300	S
228	Clear , McKee lamp	325	R
	Colored glass	450	R
229	Authenticity questionable		*
230	Colored glass, embossed	525	R
231	Colored glass, See I-#272	325	S
232	Colored, See I-#456	225	S
233	Cranberry swirl, see I-#294	425	S
234	Clear Duncan swirl	300	S
235	Clear, embossed	350	R
	Colored glass	475	R

236	Clear w/frosted See I-#148 ,151	300	S
	Blue m.g.	475	VR
	Blue satin glass	525	VR
237	Clear, complete See I-#41	500	R
238	Log Cabin, See I-#50 for price range		
239	Authenticity questionable		*
240	Authenticity questionable		*
241	Cabbage rose	125	C
242	Goofus glass, clear or m.g.(140)	125	C
243	Clear , painted	125	C
244	Porcelain, See I-#455 & II-#XLVII	350	S
245	Clear glass, embossed	150	C
246	W.M.G. ribbed and swirled	350	R
247	W.M.G. embossed	275	S
248	W.M.G. Embossed, dec.	250	S
249	White m.g. embossed	325	S
	Colored m.g.	425	S
250	W.M.G. embossed, see I-#161	250	S
251	W.M.G. pedestal	150	S
252	Harrison or Cleveland see H#133	700	R
253	Green or blue mg.	325	S
254	Colored medallion,		
	Feet ground, See #I-547	1,400	S
255	Not an old lamp		*

256	W.M.G. embossed	425	VR
	Colored m.g.	550	VR
257	W.M.G. emb. See I-#396	350	S
258	W.M.G. emb.	325	S
259	W.M.G. embossed	160	C
260	W.M.G. painted, See I-#312	350	S
261	Satin glass, May be old	450	S
262	W.M.G. painted, See I-#333	250	S
263	W.M.G. painted	300	S
264	Authenticity questionable		*
265	Authenticity questionable		*
266	Pairpoint , See I-#130	250	R
267	Pairpoint, Dresden, See H-#345	650	R
	Delft windmill scene	700	R
268	White milk glass	200	S
269	Authenticity questionable		*
270	W.M.G.	100	C
	Colored m.g.	150	C
271	W.M.G. bear	250	R
272	White milk glass	125	S
273	Authenticity questionable		*
274	Shoe, no handle, See I-#51	750	VR
275	Authenticity questionable		*
276	Authenticity questionable		*

277	Brass base, wrong shade & spider	150	S
278	Brass	55	C
279	Pewter base, new shade	200	S
280	Jr. Rochester lamp, new shade	175	S
281	B & H nickel-plated base, old shade, mismatch	400	S
282	Brass pedestal, jewels	150	S
283	Authenticity questionable		*
284	Brass pedestal lamp	150	S
285	Brass pedestal lamp	150	S
286	Brass pedestal lamp	150	S
287	Brass pedestal lamp	125	S
288	Brass pedestal lamp, See H-#107	150	S
289	Authenticity questionable		*
290	Pedestal brass base	150	S
291	Pigeon lamp	125	S
292	Authenticity questionable		*
293	Lamp-post lamp	150	R
294	Authenticity questionable		*
295	Label		
296	Student lamp, See 2-#299	850	R
297	Student lamp	750	R
298	Student lamp	700	R
299	Student lamp, See 2-#296	850	R

300	Student lamp, Age questionable	375	S
301	Student lamp, Age questionable	500	S
302	Authenticity questionable		*
303	Student lamp double barrel	1,400	R
304	Student lamp double	2,000	R
305	Student lamp, not old	800	*
306	Brass sleigh, not old	700	*
307	Brass barrel bracket	600	*
308	Brass log, pig-type lamp	450	*
309	Grand Val Time Indicator	350	R
310	Weaver Time lamp	350	R
311	Night Clock (Illustration only)	1,450	VR
312	German clock	1,200	VR
313	Authenticity questionable		*
314	Brass tray lamp	175	S
315	Authenticity questionable		*
316	Beer barrel cigar lighter	450	R
	With CB &S (colored)	700	R
317	Bisque monkey base	250	R
318	Porcelain monkey base	250	R
319	Authenticity questionable		*
320	Porcelain dog base	450	S
321	Lady Fox decorated base	450	R
322	Pug dog base	450	R

323	Porcelain dog lamp	475	R
324	Tiger head	475	R
325	Ram head	475	R
326	Majolica Bases, Incomplete	500	S
327	Bisque swan lamp	550	R
	With matching shade	650	R
328	Elephant base	450	R
329	Elephant base	450	R
330	Elephant base,		
	(shade shown for H-#310)	450	R
331	Bisque cherub lamp	400	R
332	Porcelain cherub lamp	500	R
333	Dresden lamp, signed Meissen	750	R
334	Incomplete		*
335	Authenticity questionable		*
336	Jasperware lamp	400	R
337	Girl & Boy figural lamps	675	R
338	China boy, See H-# 264,		
	not original shade	300	R
	W/ matching shade	475	R
339	China boy, not original shade	300	R
	W/ matching shade	475	R
340	China lamp	275	R
341	China lamp	350	R

364	Bristol glass decorated	400	S
365	W.M.G. painted	325	S
366	W.M.G. painted	350	S
367	White Bristol glass dec.	350	S
368	Colored glass, w/ overshot	475	S
369	W.M.G. painted, shade cut down	350	S
370	Lavender Bristol glass	425	R
371	Cobalt pedestal	275	S
372	Mismatch		*
373	Authenticity questionable		*
374	Cranberry bracket lamp	825	R
375	Cranberry, bracket lamp, incomplete	500	R
	W/ matching shade	650	R
376	Authenticity questionable		*
377	Authenticity questionable		*
378	Hanging hall lamp	600	R
379	Hanging hall lamp	600	R
380	Doll house lamp	400	R
381	Authenticity questionable		*
382	Authenticity questionable		*
383	Hanging lamp	1,975	VR
	W/ matching shade/font	3,000	VR
384	Authenticity questionable		*
385	Brass boudoir lamp	75	C

386	Brass boudoir lamp	75	C
387	Brass boudoir lamp	75	C
388	Wall hanging lamp	100	S
389	Authenticity questionable		*
390	Peg lamps	125	S
391	Glow peg lamp	100	S
392	Tin peg lamps, PR	100	S
393	Brass saucer peg lamp	50	S
394	Authenticity questionable		*
395	Pairpoint lamp, dec.	1,100	R
396	Lavender m.g. lamp	300	R
397	W.M.G. painted, See I-#320	350	S
398	Crown Milano, See I-#571	3,250	VR
399	Incomplete		*
400	Authenticity questionable		*
401	Blue or amber glass emb.	475	R
	Cranberry	550	R
402	White Bristol glass, dec.	375	R
403	Colored satin,		
	See I-#380 through #390	450	S
404	Colored satin glass, emb.	650	R
405	Porcelain lamp, dec.	400	S
406	W.M.G. painted	200	S
407	W.M.G. painted	275	S

408	Incomplete		*
409	Mismatch		*
410	Incomplete		*
411	Colored glass, pewter base	400	R
412	Colored, See I-#111	400	R
413	Colored lamp, Bohemian cut	475	R
414	Authenticity questionable, See H-#158		*
415	Incomplete		*
416	Brass base lamp	150	S
417	Silver base lamp	325	S
418	Incomplete, See H-#143		*
419	Mismatch		*
420	Three-tier banquet lamp	600	R
421	Three-tier banquet lamp	600	R
422	Brass banquet lamp	550	R
423	Three-tier banquet	350	R
424	Signed Pairpoint W.M.G. dec.	950	R
425	Silver base lamp	350	S
426	Brass Jr. banquet lamp	525	R
427	Incomplete		*
428	Silver base lamp	900	VR
429	Silver base lamp	825	VR
430	DQMOP, See I-#589 through 593	1,750	R
431	Wrought-iron lamp	350	S

432	Brass Jr. banquet lamp	450	R
433	Cloisonne lamp	850	VR
434	Brass and porcelain lamp, Pairpoint	450	R
435	Jr. banquet lamp	385	R
436	Silver base lamp	325	R
437	Pewter pedestal lamp	300	S
438	Brass Jr. banquet lamp	450	R
439	Porcelain owl lamp	675	R
440	Porcelain owl lamp	625	S
441	Owl base alone	425	S
442	Owl head base alone	375	S
443	Owl base alone	350	S
444	Stein lamp, signed Handel	2,800	VR
445	Stein lamp decorated	1,150	R
446	Mismatch, base only	450	*
447	Stein lamp	1,125	R
448	Incomplete		*
449	Mismatch		*
450	W.M.G. decorated	550	R
451	Porcelain emb., See I-# 615	525	S
452	White Bristol glass	300	S
453	Satin glass , embossed	725	R
454	Colored cased glass	1,600	R
455	Authenticity questionable		*

456	Colored satin glass, See II-# L	1,575	R
457	Authenticity questionable		*
458	W.M.G. See H-# 111 & #113	300	C
459	Colored satin glass embossed	1,775	R
460	Bristol glass decorated	325	S
461	DQMOP, not an old lamp		*
462	DQMOP, not an old lamp		*
463	DQMOP, not an old lamp		*
464	Mismatch		*
465	Clear glass painted satin	400	S
466	Colored spatter glass	735	R
467	Vaseline opalescent	1,650	VR
468	Mismatch		*
469	Spatter Glass	1,800	R
470	Colored frosted glass, emb.	375	R
471	Colored log lamp	375	R
472	Authenticity questionable		*
473	Cranberry dec.	500	S
474	Cranberry glass, dec.	600	S
475	Colored glass decorated	550	S
476	Colored glass decorated	500	R
477	Cranberry, Moser glass	600	R
	Green	525	R
478	Cranberry glass, See II-# 544	875	S

479	Overshot, decorated	675	R
480	Colored iridescent dec.	550	S
481	Clear overshot, enamel dec.	450	R
482	Mismatch		*
483	Clear glass painted satin	385	R
484	Clear glass frosted	400	R
485	Amberina glass swirl	555	R
	Cranberry	475	R
486	Authenticity questionable		*
487	Incomplete		*
488	Incomplete		*
489	Incomplete		*
490	Incomplete		*
491	Incomplete		*
492	Not old		*
493	Mismatch		*
494	Green, amber glass	1,000	R
495	Green glass	1,225	R
	Cranberry	1,500	R
	Amberina	1,800	R
496	Cobalt, See I-# 470 for range	475	R
497	Amber glass, no dec., See II-# 227	285	S
498	Teal blue, Age questionable	275	R
499	Cranberry diamond quilt	700	R

500	Cranberry opl. diamond	875	VR
501	Authenticity questionable		*
502	White opl. Bristol glass	325	R
503	Cranberry opl. not an old lamp		*
504	Authenticity questionable		*
505	Cranberry opl. swirl	1,525	VR
506	Cranberry opl. stripes	1,100	R
507	Authenticity questionable		*
508	White opl. Polka Dot	1,000	VR
	Blue Polka Dot	1,150	VR
509	Stumpf Monet pink opl	1,350	VR
510	Colored opl. glass, See H-# 354	1,000	VR
511	Colored opl. glass	750	R
512	Vasa Marrhina	500	R
513	Colored glass, embossed swirl	850	VR
514	Cranberry glass, ribbed swirl	1,000	VR
515	Mismatch		*
516	Colored cased, See II-# XLIV	800	R
517	Colored satin glass, See H-#314	1,550	R
518	Parian glass embossed	730	R
519	Amber crackle overlay,		
	See H-# 344	2,100	VR
520	Cranberry diamond,		
	See H-#528 & 338	1,450	R

521	Amber glass honeycomb	825	R
522	Authenticity questionable		*
523	Pink or blue m.g. w/filigree	2,200	VR
524	Mother-of-pearl, raindrop	2,300	VR
525	Authenticity questionable		*
526	Authenticity questionable		*
527	Fireglow lamp, See H-#309	2,100	VR
528	Fireglow decorated	2,000	VR
529	Blue satin glass, poss. Webb	1,475	VR
530	Cream satin glass, rust dec.	1,300	VR
531	Burmese dec. Webb, See H-#435	3,400	VR
532	DQMOP w/ coralene dec.	5,000	VR
533	DQMOP colored	2,600	VR
534	DQMOP colored	3,000	VR
535	Blue overshot	1,200	R
	Cranberry	1,350	R
536	Mother-of-pearl melon ribbed	2,700	VR
537	Overshot colored glass	1,600	VR
538	Pink opl. threaded, ribbed	2,000	VR
539	Pink opl. threaded, ribbed	2,000	VR
540	Opl. ribbed, swirled design	2,500	VVR
541	Cameo lamp	8,700	VR
542	Verre Moire (Nailsea)	4,900	VR
543	Pink, yellow, incorrect shade		*

	W/ correct ball shade	1,800	VR
544	Cranberry, See II-# 478	875	R
545	Goofus lamp	150	C
546	Mismatch		*
547	Rainbow cut glass	7,100	VR
548	Blue or Maroon spatter glass	1,700	R
549	DQMOP satin glass	3,000	VR
550	End-of-day cased glass	1,500	VR
	Blue or pink and white cased	1,600	VR

PRICE GUIDE FOR
MINIATURE VICTORIAN LAMPS

by Marjorie Hulsebus

HULSEBUS

NO.	DESCRIPTION	PRICE ($)	RARITY
1	Star Lamp	100	S
2	Nightwatch	200	S
3	Blue finger lamp	250	S
4	White opaline	225	S
5	Novelty Night Lamp	100	S
6	W.M.G. dec.	175	S
7	Dresden	225	R
8	Colored Bristol	175	S
9	Silver	200	S
10	Colored finger lamp, See II-#100	100	S
11	Shiwi	150	R
12	Blue Sunlight, See II-#92	150	S
13	Clear bracket lamp	450	R
14	Brass saucer lamp	150	S
15	Clear saucer lamp	125	S
16	Continental, early burner	175	R
17	Time lamp	300	R
18	Clear beehive, early burner	140	S
19	Little Pearl, early burner	150	S
20	Clear finger lamp	175	S
21	Amethyst	125	S
22	China head	250	S

23	Cobalt finger lamp	135	S
24	Not old		*
25	Blue finger lamp	125	S
26	Green opaline	175	S
27	Little Jim	200	S
28	Blue opaline	175	S
29	Improved Little Wonder	150	S
30	Blue m.g.	350	S
31	Blue opaline	175	S
32	Clear	125	S
33	Cobalt Little Harry	400	VR
34	Improved Little Favorite	150	S
35	Clear font	100	S
36	Clear beehive	100	S
37	Clear Sun Night Lamp	100	S
38	Green m.g. finger lamp	175	S
39	Cranberry finger lamp	275	S
40	Blue finger lamp	175	S
41	W.M.G. dec.	175	S
42	Cobalt or Teal Little Harry's		
	Night Lamp	600	VR
	Clear	400	R
43	Helen's Baby	125	S
44	Imperial Crown	125	S

45	The Boss	125	S
46	Clear glass, VR Tom Thumb burner	450	R
47	Clear finger lamp, w/ correct burner	250	S
48	The Trilby Night Lamp	100	S
49	Clear inv. baby thumbprint	225	S
50	Lavender opaline	200	R
51	Little Vesta Eradicator	150	S
52	Green embossed	200	R
53	W.M.G. dec.	275	S
54	Greenish opaline	200	S
55	Silver cigar lighter	250	S
56	Delft	300	R
57	Pewter embossed	200	S
58	W.M.G. dec.	275	S
59	White Bristol	175	S
60	Matchless	200	S
61	White Bristol	250	S
62	Amber optic rib base	200	S
63	Clear optic rib, complete	450	S
64	Amber or blue stem	175	S
	Clear	140	S
65	Amber six panel	175	S
	Clear	140	S
66	Blue Pickett	200	R

	Clear	140	S
67	Clear stem, poss. whale oil	150	S
68	Cranberry opl. (clear 150)	300	S
	Blue or Vaseline	250	S
69	Clear stem	125	S
70	Westward Ho	375	S
71	Frosted stem	175	R
72	Colored Bloxam stem	300	R
	Clear Bloxam	150	R
73	Clear glass embossed	200	S
74	Clear dec.	200	S
75	Metal pedestal lamp	185	S
76	Clear pressed glass	275	S
77	Clear stem lamp	375	R
78	Clear glass Nellie Bly type	175	S
79	Clear glass ribbed/ embossed	285	S
80	Cobalt Little Harry, bracket	1,400	VVR
81	Clear Evening Star, bracket	675	VR
82	Clear Little Lilly, bracket	675	VR
83	Cobalt bracket lamp	750	VR
84	Firefly bracket	725	VR
85	W.M.G. Night Watch, bracket	700	VR
	WCB & C	800	VR
86	W.M.G., bracket	550	VR

87	Porcelain clock	375	R
88	Schering's Formalin lamp	140	S
89	Brass traveling lamp	300	R
90	Brass hanging glow lamp	175	S
91	Brass finger lamp	100	S
92	Brass traveling clock	1,400	VR
93	French's warmer	175	R
94	Brass skater's lantern	300	S
95	Brass skater's lantern	300	S
96	Brass skater's lantern	400	S
97	Brass skater's lantern	300	S
98	Brass skater's lantern	300	S
99	Brass skater's lantern	275	S
100	Clear cigar lighter	600	R
	Colored glass	775	R
101	Brass cigar lighter	225	R
102	Brass student lamp	1,200	VR
103	Admiral Dewey lamp, either size	975	R
104	Brass embossed lamp	250	S
105	Metal carrying lamp	100	S
106	Brass student lamp	1,150	S
107	Brass pedestal lamp	150	S
108	Aqua satin glass	300	S
109	W.M.G. dec. may not be old	225	*

110	Blue m.g., may not be old	250	*
111	Cobalt emb., may not be old	300	*
112	Cobalt emb., may not be old	400	*
113	White emb., may not be old	300	*
114	Spatter glass, may not be old	150	*
115	Stained glass ornament		
116	Pale blue opl., not an old lamp	200	*
117	Raspberry or yellow DQMOP,	300	*
118	W.M.G. dec.	150	S
119	Green embossed	150	S
120	W.M.G. finger lamp	125	S
121	Green glass embossed	150	S
122	Blue glass lamp	175	R
123	Cranberry glass lamp	225	R
124	Amethyst glass lamp	200	R
125	Blue glass lamp	200	R
126	W.M.G. dec.	350	R
127	Butterscotch opaque lamp	400	R
128	W.M.G. emb.	150	C
129	White satin embossed	400	R
130	Green m.g. embossed	400	R
131	W.M.G. embossed	300	S
132	W.M.G. dec.	375	R
133	Cleveland lamp	700	R

134	White satin, decorated	325	S
135	W.M.G. painted	350	S
136	W.M.G. decorated	350	S
137	W.M.G. decorated	400	S
138	Bristol glass decorated	350	S
139	Green painted m.g.	350	R
140	W.M.G. painted	350	S
141	Opaque overshot	275	S
142	W.M.G. satinized	375	S
143	Delft , porcelain	550	S
144	Delft , porcelain	400	S
145	W.M.G. decorated	375	S
146	Green satinized, dec.	375	S
147	W.M.G. embossed	250	S
148	Gold painted glass, dec.	350	S
149	Aqua Bristol glass, dec.	375	S
150	Blue m.g. ribbed	550	S
151	Blue Bristol, dec.	375	S
152	White Bristol, dec.	350	S
153	Pink cased, dec.	550	S
154	White opaline	350	S
155	Pink opaline	375	S
156	Purple Bristol dec.	525	R
157	W.M.G., dec.	350	S

158	Ruby cut to clear, vintage (?)	275	S
159	Amber, embossed	275	S
160	Blue glass, decorated	375	S
161	Cranberry swirl	450	S
162	Green or amber, dec.	450	S
	Cranberry dec.	525	S
163	Cranberry w/ gold dec.	475	S
164	Colored glass, dec.	450	S
165	Blue glass, decorated	700	S
166	Aqua glass, embossed	400	S
167	Blue glass, embossed	400	S
168	Green glass, enamel dec.	450	S
169	Rubina textured glass, dec.	675	S
170	Green glass, decorated	450	S
171	Clear satinized, decorated	700	S
172	Clear frosted pink, dec.	450	S
173	Green to gray overshot glass	450	S
174	Green satinized, dec.	350	S
175	Blue satinized glass, dec.	400	S
176	Painted peach Bristol, dec.	400	S
177	W.M.G., decorated	375	S
178	Green m.g., decorated	400	S
179	W.M.G., decorated	400	S
180	Clear frosted green, dec. .	350	S

181	Bristol glass decorated	425	S
182	Tomato red or yellow cased	500	S
183	Bristol glass, decorated	425	S
184	W.M.G. decorated	375	S
185	Aqua Bristol glass, decorated	425	S
186	Blue m.g., ribbed and embossed	875	R
187	Brass pedestal lamp	300	S
188	Blue porcelain, dec.	350	S
189	Clear glass, frosted, dec.	375	S
190	Brass pedestal lamp	375	S
191	Blue satin glass, embossed	1,600	R
192	Pink glossy lamp	450	S
193	Blue satin glass, embossed	850	S
194	Pink cased	450	S
195	Pink satin glass, embossed	550	R
196	Blue glass, embossed	425	S
197	Pink cased pedestal	475	S
198	Blue glass, enamel dec.	825	S
199	Clear opl. reverse swirl	1,200	R
200	Cranberry opl. windows	1,600	R
201	Blue double handled lamp	1,400	S
202	Rose iridescent, dec.	550	S
203	Green iridized, dec.	475	S
204	Blue honeycomb	500	S

205	Blue or honey reverse swirl,		
	see H-#320	725	S
206	Green inverted thumbprint	600	S
207	Green geometric	375	S
208	Green paneled	325	S
209	Green, enamel dec.	575	S
210	Cranberry glass, enamel dec.	600	R
211	Cranberry glass	725	R
212	Cranberry, Mary Gregory dec.	875	R
213	Cranberry glass, embossed	600	R
214	Cranberry glass	450	S
215	Green embossed	300	S
216	Cranberry beaded, finger hold	575	S
217	Cranberry, enamel dec.	625	S
218	Cranberry, enamel dec.	625	S
219	Green, enamel dec.	600	S
220	Cranberry, enamel dec.	625	S
221	Blue glass, embossed	475	S
222	Cranberry glass, embossed	525	S
223	Blue ribbed swirl lamp	525	R
224	Blue embossed, finger hold	450	R
225	Cranberry embossed, finger hold	500	R
226	Blue satin, embossed	400	S
227	Cranberry , swirl	625	S

228	Cranberry, "flying saucer"	550	S
229	Cranberry paneled, see 2-#523	700	S
230	Ruby red etched, age questionable	300	S
231	Green pedestal	225	S
232	Ruby red paneled	350	S
233	Cream porcelain base, util. shade	300	S
234	Cranberry, enamel dec.	525	S
235	Bisque court jester	425	S
236	Blue and yellow porcelain	300	S
237	Bisque boy figural, incomplete	150	*
238	Bisque girl figural, incomplete	150	*
239	Bisque basket weave lamp	425	S
240	White porcelain cat	600	S
241	White porcelain cat	600	S
242	Porcelain owl lamp	675	S
243	Cherub base, shape not original	500	S
244	White bisque cherub lamp	450	S
245	Blue bisque cherub lamp	450	S
246	Bisque clown lamp	600	S
247	White sitting kitten	275	S
248	Majolica-type Toby	275	S
249	White porcelain cat	250	S
250	Boy next to egg figural	350	S
251	Black Boy Hooda	500	S

252	White porcelain poodle	525	S
253	Bisque girl w/ vase	375	S
254	Porcelain collie dog	600	S
255	White porcelain dog	525	S
256	Brown porcelain monkey	675	S
257	China figural boy	225	S
258	Bisque girl in basket	450	S
259	China cherub lamp	350	S
260	Bisque tree trunk	175	S
261	China boy w/barrel	200	S
262	Bisque cherub /egg	425	S
263	Bisque girl w/bee hive	450	S
264	White china girl	300	S
265	Porcelain lion head	500	S
266	White porcelain owl head	475	S
267	Porcelain dog peg lamp	475	S
268	Porcelain terrier lamp	500	S
269	W.M.G. owl lamp	325	S
270	Bisque artichoke-type lamp	500	S
271	White china clown	400	S
272	Pairpoint candle lamp	1,000	R
273	T V Limoges peg lamp	825	R
274	Composite lamp	375	S
275	Composite base	275	S

276	Capo de Monte owl lamp	7,100	VR
277	Parian owl lamp	2,675	VR
278	Green m.g. cupid lamp	450	R
279	Dresden-type elephant w/handles	325	S
280	Delft finger lamp	225	S
281	Colored m.g. comical man	375	S
282	Aqua basket weave	300	S
283	Royal Worcester	675	S
284	Blue porcelain lamp	375	S
285	White porcelain , dec.	450	S
286	Silver base lamp	300	S
287	Bisque girl next to basket	375	S
288	Copper emb. base lamp	275	S
289	White Bristol," God Natt"	350	S
290	W.M.G., embossed, dec.	325	S
291	White porcelain, emb., dec.	475	S
292	Mesier lamp	750	S
293	W.M.G. decorated	675	S
294	W.M.G. 2-tier Jr. banquet	475	S
295	W.M.G., decorated	375	S
296	Banquet lamp, Ionic Princess	700	S
297	W.M.G. decorated	365	S
298	White Bristol glass, dec.	850	S
299	White Bristol glass, dec.	550	S

300	W.M.G. decorated	775	S
301	Blue honeycomb lamp	600	S
302	Blue opalescent	1,700	R
303	Yellow opalescent	1,700	R
304	Rubina honeycomb	1,000	R
305	Blue m.g. w/silver filigree	500	R
306	Vasa Marrhina lamp	1,800	VR
307	DQMOP, rose or blue	2,300	VR
308	Honey-mustard satin, dec.	1,500	R
309	Fireglow decorated	2,200	VR
310	Apricot satin glass, dec.	1,575	R
311	Raspberry satin glass, swirl	1,350	R
312	Blue Mother-of-pearl raindrop	1,800	VR
313	Pink satin glass embossed	1,700	R
314	Chartreuse satin glass, emb.	1,550	R
315	White opalescent glass	775	R
316	White opl. satin glass	925	R
317	Blue snowflake	1,050	R
	Cranberry snowflake	1,150	R
	White snowflake	850	R
318	Cranberry pedestal-type	875	R
319	Blue Mary Gregory type	800	R
320	Pink candy-stripe, cased	875	R
	Clear overshot	600	R

321	Honey amber opalescent	700	R
322	Pink & white ribbed dewdrop	985	VR
323	Pink candy-stripe reverse swirl	1,700	R
324	Pink candy-stripe swirl	1,600	R
325	Green candy-stripe satin glass	2,000	R
326	Pink candy-stripe cased	1,625	R
327	Blue Mother-of-pearl raindrop	2,000	VR
328	Pink candy-stripe cased	2,075	VR
329	EOD, ribbed, swirled	1,850	R
330	Blue clear glass pedestal	600	S
331	Pink candy-stripe cased	1,550	R
332	Blue to clear lamp	800	S
333	Textured glass, enamel dec.	1,125	R
334	Textured glass, enamel dec.	1,325	VR
335	Vaseline opl.. reverse swirl	2,450	R
336	Honey opl. reverse swirl	2,600	R
337	Aqua opl, matching chimney	2,000	R
338	Cranberry diamond quilt	1,450	R
339	Blue opl., matching chimney	1,800	R
340	Amber paneled	975	S
341	Pink cased, opl. match chimney	2,175	VR
342	Cranberry swirl, match chimney	1,950	VR
343	Yellow opaque, ribbed, swirl	1,600	R
344	Blue crackle overlay	2,100	VR

345	White satin dec., poss. Pairpoint	1,100	R
346	Custard glass lamp	1,300	R
347	Yellow satin, poss. Webb	2,000	VR
348	Chartreuse to clear, frosted	1,650	R
349	Pink or blue crackle overlay	1,850	R
350	Raspberry cased w/Mica	2,500	VR
351	Raspberry m.g. ribbed, swirl	1,550	R
	Yellow, blue, glossy or satin	1,500	R
352	Blue DQMOP, cased	2,000	R
	Pink or rose, cased	2,000	R
353	Silver peg, pink 'pulled thread'	1,800	R
354	Vaseline or blue opl.. satin	1,075	R
355	Pink satin w/silver filigree	850	S
356	Colored m.g. w/silver filigree	1,075	R
357	Dep rose m.g. silver filigree	1,185	
358	B & H embossed base lamp	575	R
359	Silver base, Peachblow shade	700	R
360	Imari base lamp	375	S
361	Baccarat lamp	500	S
362	Metal embossed lamp	350	S
363	Brass embossed lamp	400	S
364	Metal embossed lamp	375	S
365	Cloisonne lamp	500	S
366	Silver base, Pulled thread shade	650	S

367	Silver base, pink opl. shade	575	S
368	Metal base, green frosted shade	450	S
369	Silver base, blue & white shade	500	S
370	Blue Baccarat base, acid etched	375	S
371	Silver base, blue cameo shade	800	S
372	Silver base, blue Nailsea shade	600	S
373	Brass base, pink opl. shade	575	S
374	Silver base, Nailsea shade & ch.	2,300	VR
375	Textured opaque, decorated	575	S
376	Lavender opaque, decorated	925	R
377	Textured glass, enamel dec.	625	S
378	Pink cased embossed	1,075	R
	Blue or yellow	1,100	R
379	Iridescent green peg lamp	1,000	R
380	Yellow cased embossed	1,450	R
	Pink or blue	1,400	R
381	Cranberry ribbed and swirled	900	S
382	Amber textured glass	900	S
383	Iridescent wine pedestal	1,700	R
384	Pink crackle overlay	2,500	VR
385	Vaseline opl. striped	1,900	VR
386	Pink Mother-of-pearl, ribbed	2,400	VR
387	Vaseline opl. striped	1,875	VR
388	Cranberry to clear	1,450	R

389	Vaseline opalescent striped	1,725	VR
390	Cranberry opl. swirl	1,600	R
391	Blue opl. vertical stripe	1,475	R
392	Cranberry, optic rib	1,400	R
393	Aqua op. vertical stripe	1,475	R
394	Cranberry hobnail	1,300	VR
395	Amber hobnail	1,175	VR
396	Cranberry overshot	2,000	VR
	Green overshot	1,865	VR
397	Rubina overshot ribbed	2,175	VR
398	Cranberry paneled	2,400	VR
399	Rubina overshot w/rigaree	2,450	VR
400	Rubina Verde crackle glass	2,900	VR
401	Amber & pigeon blood	2,600	VR
402	Vaseline opl. vertical stripe	2,600	VR
403	Blue or pink marble-type glass	2,600	VR
404	Blue or pink marble-type glass	2,800	VR
405	Pink cased ribbed, decorated	2,600	VR
406	Pink cased satin glass	1,350	R
407	Frosted glass, blue loopings	1,200	VR
408	Green satin, geometric dec.	1,250	VR
409	Green pedestal, gold dec.	1,825	VR
410	Vaseline/cranberry, gold dec.	2,050	VR
411	B & H metal base, Bristol sh.	425	R

412	Cranberry Nailsea, brass peg	2,000	VR
413	White/cranberry Nailsea	3,000	VR
414	Blue quilted pattern glass	1,050	R
415	Pink cased 3-tier satin glass	5,125	VVR
416	Cranberry Inverted thumbprint	1,350	R
417	Cranberry pulled thread, finger hold	2,200	VR
418	Blue cut velvet diamond pattern	2,600	VR
419	Yellow, pink, orange spatter	2,125	VR
420	Blue inverted thumbprint	1,600	R
421	Raspberry ribbed cased	4,500	VVR
422	Yellow Nailsea lamp	3,900	VVR
423	Blue Mother-of-pearl, raindrop	4,000	VR
424	Apricot Mother-of-pearl, ribbed	3,800	VVR
425	Blue DQMOP vertical ribbed	3,500	VVR
426	Mother-of-pearl, pink w/blue	3,650	VVR
427	Blue or yellow cased satin	1,500	R
428	Rainbow DQMOP, challis	3,900	VR
429	Tiffany Favrile, Jr. size	4,100	VR
430	Green Aventurine glass	900	R
431	Green Honesdale cased glass	2,650	VVR
432	Blue Webb cameo	8,750	VR
433	Cranberry Nailsea, matching chimney	4,000	VR
434	Webb Peachblow	3,500	VR

435	Acid etched Burmese	6,750	VVR
436	Pink Nailsea, poss.		
	Stevens & Williams	7,000	VVR
437	Blue DQMOP w/coralene, Webb	6,000	VVR
438	Blue 3 piece Nailse,		
	matching chimney.	6,500	VVR
439	Pink cased , Stevens & Williams	2,600	VVR
440	Acid Burmese, dec., Webb	8,400	VVR
441	Blue Cameo, Webb	15,800	VVR
442	Tri-colored Cameo, Webb	16,000	VVR

PRICES FOR REPRODUCTIONS

shown in *Miniature Victorian Lamps*, pages 8 & 9

SMITH NO.		PRICE ($)
50	Log Cabin	50
110	Colored Bulls-eye, screw on collar	25
203	W.M.G. & Cased colored	175-225
397	Peach Satin Glass	50
400	Drape, W.M.G. or Cased	125-175
403	Glossy beaded drape	125-175
419	Rainbow/colored glass	125-200
434	Cranberry IVT	200-250
482	Daisy & Cube	125-175
II-503	Cranberry opalescent	250-300
	Moon & Stars	75-125
	Blue Opl. Moon & Stars	125-175